Ai Weiwei

A Selective Annotated Bibliography of Dissertations and Theses

Elizabeth J. Hester

Copyright © 2016 Elizabeth J. Hester

All rights reserved.

No part of this book may be used or reproduced in any manner whatsoever without the written permission of the author.

Hester, Elizabeth J.

Ai Weiwei: A selective annotated bibliography of dissertations and theses/Elizabeth J. Hester

p. cm.

1. Ai Weiwei – Criticism and interpretation. 2. Ai Weiwei – Contemporary artist. I. Title.

N 7349 .A5
709.2

ISBN-10 1537058444

ISBN-13 978-1537058443

Cover photo – Beijing National Stadium, "The Bird's Nest" designed by Ai Weiwei in collaboration with Herzong and de Meuron, 2007.

Table of Contents

1.) **Amien, Z.** ... 1
"Real" lives and "ordinary" objects: Partisan strategies of art making with garment makers of the Western Cape.

2.) **Bouries, E.** ... 3
Une perspective sur les avant-gardes et la question de la modernité en Chine au vingtième siècle (1976-2003) (Translated Title - Art and Revolution: A perspective on the avant-garde and the question of modernity in China in the twentieth century (1976-2003).

3.) **Chen, A.** ... 5
House of seals: Stamping the old in contemporary China.

4.) **Dörler, F.** **8**
Die Wahrnehmung Chinas im Westen: Die Darstellung eines chinesischen Künstlers in den deutschsprachigen Medien, am Beispiel Ai Weiweis. (Translated Title - The perception of China in the West: The representation of a Chinese artist in the German media, the example of Ai Weiwei).

5.) **Fok, S. H. S.** **10**
Performance art and the body in contemporary China.

6.) **Holmes, R. M.** **14**
'Civilising' China: Visualising wenming in contemporary Chinese art.

7.) **Hughes, J. L.** **17**
Terms and conditions.

8.) **Lawson, V.** **19**
Embodied artistic interventions into the tourist field.

9.) **Liu, I.** ..21
Research on the contemporary artist Ai Weiwei - A side write about the archetype of the eschatological hero or the rise of the hero.

10.) **Merki, P.** ..24
Censorship in Chinese media: A comparison of Ai Weiwei and Han Han.

11.) **Parker, L. M.**25
Incipiendum, Ad Infinitum: Considerations for an ethicopolitical framework and the potential for art as its expression.

12.) **Quick, G. C.**28
Art and the politics of Neoliberal subjectivity: The activist artist in the East Village, 1981-1993.

13.) **Sikes, E.** ..30
A matter of perspective: Anti-authoritarian gestures in the political art of Ai Weiwei.

14.) **Wang, W.** 32
Censorship and subtle subversion in Chinese contemporary art.

15.) **Yu, T.** 34
'My' self on camera: First person DV documentary filmmaking in twenty-first century China.

16.) **Zheng, B.** 37
The Pursuit of publicness: A study of four Chinese contemporary art projects.

Locating Dissertations and Theses 39

Ai Weiwei

A Selective Annotated Bibliography of Dissertations and Theses

1.) **Amien, Z.**
"Real" lives and "ordinary" objects: Partisan strategies of art making with garment makers of the Western Cape.
M.F.A thesis, University of Cape Town (South Africa). 2016.

In this project, located in the Western Cape, I converge with local artists, Gerard Sekoto and Siona O'Connell, as well as international artists such as Ai Weiwei in China, Jun Nguyen Hatsushiba in Vietnam and Doris Salcedo in Colombia. We all deploy ordinary objects to work against a range of hegemonic paradigms, expressing the plight of marginal communities in varying but connected ways. These "ordinary" objects, through the unique vision of the artist, become more than mere instruments of labour, or even mere metaphors for the workers' plight: they become part of a partisan aesthetic. The manner in which

Sekoto, Nguyen Hatsushiba, Weiwei, Salcedo and O'Connell use ordinary objects like the pick, the rickshaw, the sunflower seed, the table/shoe and the ball gown to address globalisation, modernisation, the plight of the worker, the consequences of colonialism and war and how we live in the aftermath of an oppressive regime inspired me to use ordinary objects to create political art and render the lived realities of garment workers in the Western Cape. Scholars like Paulo Freire, Achille Mbembe, Anthony Bogues and Jacques Rancière undergird these kinds of aesthetic projects, with their discourse on oppression, freedom and emancipation. [Author Abstract]

2.) **Bouries, E.**
Une perspective sur les avant-gardes et la question de la modernité en Chine au vingtième siècle (1976-2003) (Translated Title - Art and Revolution: a perspective on the avant-garde and the question of modernity in China in the twentieth century (1976-2003).
Ph.D. dissertation, Paris Institute of Political Studies (France). 2011.

This thesis considers the institutionalization of the concept of Contemporary Chinese Art. The main issue is drawn on the analysis of expressions of cultural distinctiveness and its link to the question of modernity. Mostly regarded as the manifestation of a globalized art, Chinese contemporary art conceals in fact a complex evolutionary process. The claim that a gap, or even a break-away, between the evolution of art in the Western World and China, initiated many debates. The study of the

artistic movements involved in the ideological emancipation process, after the death of Chairman Mao in 1976, (Xingxing, bawu yundong), shows a split between supporters of an artistic activism on the one side and partisans of a formal approach taking better account of developments in Western art on the other. Likewise, art perceived as an echo to the many changes sweeping the country since the 1990s has stimulated controversies on the role of social contest in contemporary art - through the return to realism (Cynical Realism, Gaudy Art) or the specificity of the revolutionary experience (Political Pop). Follows the emphasis on environmental data (Beijing) entertained by critics (Li Xianting, Gao Minglu), deeply condemned by artists and critics who were living abroad (Fei Dawei, Huang Yongping); also, there persists a rebellious stance (Ai Weiwei, Gao Shiming) aiming beyond the limits of denouncing Western attitude. [Author Abstract]

3.) **Chen, A.**
House of seals: Stamping the old in contemporary China.
M.A. thesis, University of Auckland (New Zealand). 2013.

As China embraces modernism as she understands it in the scramble to showcase her newly acquired financial status to make a mark on the world stage, it is evident that in the commotion, the simplistic elegance of traditional and vernacular architecture is being generally overlooked by developers and most native architects. The temptation is to be like the rest of the world. But oil is not water, and Global is not Local, and the chief loss when the former floods the latter is the tapestry of culture - variety and uniqueness, identity basically. This thesis suggests that, in fact, local architecture in the form of the vernacular that has grown over time and out of the people of a particular place has still a lot to inform the present with its far higher

rate of architectural production in virtually borderless contexts. The subject is cultural continuity in the architecture of China in present times, and this research seeks to provide a bridge between static traditional architecture and fluid contemporary expressions. It identifies the transitional, convoluted period of experiments in engagement with Western influences (1840-1976) before discussing the work of Wang Shu, Ai Weiwei and Liu Jiakun - local architects who approach the subject with intelligence and originality. The design portion of this thesis tackles a museum of the Chinese craft of seal-making, situated in Xitang (Zhejiang Province), China. The traditional art of seal making is as representative as any other of China's vast array of undying arts and crafts, a visitor interpretive centre dedicated to continuing influence of seals in Chinese society has been chosen as the contextual grounds for investigations into and propositions on

cultural continuity in Chinese architecture. The thesis shows that traditional architectural elements, hold the best promise of an intelligent, sympathetic and redemptive approach to negotiating the onslaught of wealth as China continues to build for an ancient culture. The architectural elements (read abstractions) of enclosure, horizontal emphasis, strong axial plan, hierarchy, material and cosmological concepts are essential heritage of traditional Chinese architecture. This thesis argues that heritage, by its very definition, should be treasured, inspirational, and reinterpreted to sustain culture. [Author Abstract]

4.) **Dörler, F.**

Die Wahrnehmung Chinas im Westen: Die Darstellung eines chinesischen Künstlers in den deutschsprachigen Medien, am Beispiel Ai Weiweis. (Translated Title - The perception of China in the West: The representation of a Chinese artist in the German media, the example of Ai Weiwei).
B.A. thesis, St. Gellen University (Switzerland). 2014.

This thesis examines what image of China is drawn in the German media, and shall express its reporting on the arrest of Chinese artist and dissident by the Chinese authorities on April 3, 2011 as an example. China is considered very critical in the West, because the Western notions of the role that an economic and politically strong China should occupy in the international system come into conflict in many areas with Chinese ideas to. Analysis of the reporting on Ais arrest is carried out using the online

presences of six national German newspapers and shows that AIs demand for reforms in the West is not in question, while the Chinese government is perceived as a repressive system. [Author Abstract]

5.) **Fok, S. H. S.**
Performance art and the body in contemporary China.
Ph.D. dissertation, University of Hong Kong (Hong Kong). 2008.

This thesis examines the historical development of performance art (xingwei yishu) in contemporary China since the mid-1980s. Xingwei yishu is the most common term used to connote the enactment of a performance by the artist's body. This thesis aims to look into the specific role the artist's body plays in Chinese performance art. The first chapter examines the diverse roles the body plays in relation to the site in different performance works to reveal its historical development. Comparison of performance works with similar content and body language is made. Works by Xiao Lu, Wu Shanzhuan, Shu Yang, Pan Xinglei, Song

Yongping, Ai Weiwei, Zhang Huan, Yang Zhichao, Zhu Fadong, Li Wei, Cang Xin, Gao brothers, Zhan Wang, He Yunchang, Li Haibing, Luo Zidan, Kong Yongqian, Lin Yilin, Wang Wei, Song Dong, Qiu Zhijie, Yin Xiuzhen, Wang Jin, Young Hay, Zheng Lianjie, Wang Chuyu, Liu Jin, Wang Wei, Liu Wei, Shi Qing, Zhang Hui, Wu Ershan, Xiao Xiong and Qin Ga are examined. In addition, the second chapter scrutinizes nudity in Chinese performance art. The history of nudity in performance art as compared with other art forms pinpoints an unstable power relation between performance artists and the authorities. By analyzing ten performance works in the nude from 1984 to 2004 by Wang Peng, Concept 21, Qi Li, SHS Group, Ma Liuming, Zhang Huan, East Village Artists, Zhu Ming, He Yunchang and He Chengyao, it offers a historical study of the transformation of this genre in contemporary China. Lastly, the third chapter examines different approaches in representing life and

death through the body in performance art. There is a significant development from performing in a symbolic way appropriating ritual symbols to directly engaging animal bodies and/or corporeal materials with the artist's body. The controversies of exploiting animal bodies and corpses overwhelm the art circle and society. Works by Wei Guangqing, Wang Youshen, Huang Yan, Zhu Gang, Zhou Bin, Lanzhou Art Army, Neo-History Group, Gu Kaijun, Huang Rui, Dai Guangyu, Sun Yuan and Peng Yu, Xu Bing, Zhang Peili, Yang Zhenzhong, Wang Jin, Wang Chuyu, Zhang Shengquan, Xu Zhen, Wu Gaozhong and Zhu Yu are examined. This study shows that it is through pinning down the role of the artist's body can we grasp the impact of the body and different relationships represented in each of these works. This thesis focuses on the diverse roles and impact of the artist's body in Chinese performance art: be it personal, socio-cultural or political. It offers a contextual

analysis that representation of the artist's body is enhanced along with other artistic developments in contemporary China. [Author Abstract]

6.) **Holmes, R. M.**
'Civilising' China: Visualising wenming in contemporary Chinese art.
Ph.D. dissertation, University of Oxford (United Kingdom). 2015.

This study examines how the discourse of wenming (civilisation/civility) has been visualised throughout twentieth century Chinese art, with a particular emphasis on contemporary practice. Originally linked to concepts of modernity and change in the early twentieth century I argue that wenming continues to be of crucial importance in understanding how contemporary China wishes to be seen by the rest of the world. Through a series of close visual readings and case studies I explore how wenming attained considerable saliency as it was invoked to address a range of artistic and political reforms which resulted from China's socioeconomic transformations. Individual chapters focus on

the work of Sun Yuan and Peng Yu, Liu Gang, Wang Jin and Ai Weiwei amongst others. Taken together they provide an emic account of artistic praxis that seeks to understand contemporary art from China on its own terms. The study begins by examining how wenming was visualised in the early twentieth century. It then charts what happened to the term after the founding of the PRC in 1949 and how its appearance in locations such as Taiwan and Hong Kong provide sites of contention and alterity to mainland wenming discourse. It analyses how the bifurcation between material civilisation and spiritual civilisation that gained prominence following the economic reforms of the 1980s reconfigured the visual art of this period. Then, turning to a single art work, it theorises the relationship of wenming to an emerging corporeal politics. Finally, it explores how the discourse of wenming is being visually articulated in contemporary China as a result of these

developments and traces its interaction with consumer culture, urbanisation and the politics of the internet. [Author Abstract]

7.) **Hughes, J. L.**
Terms and conditions.
M.F.A. thesis, University of Maryland. 2015.

Terms and Conditions examines the influence that free market fundamentalism has had in constructing American identity and democratic values; the rise of corporate authoritarianism in the West; and creative actions that seek to challenge ideological narratives in the media. Borrowing ideas and creative strategies from theorists Roland Barthes, Michael Foucault, Slavoj Žižek, and David Lyon; journalists Naomi Klein and Jeremy Scahill; artists Kendell Geers, Michael Rakowitz, and Ai Weiwei, I seek to explore the socio-political mythologies of mass culture. The sculptures, prints, and video works accompanying Terms and Conditions utilizes patterning, process, scale, and repetition to reimagine the psychological capital of dominant power. My intention is to create works that are objects of inquiry by

reflecting on the transcendental process of labor and craft. At the same time the materiality of these works encourage the viewer to consider the larger social and political issues at stake. [Author Abstract]

8.) **Lawson, V.**
Embodied artistic interventions into the tourist field.
Ph.D. dissertation, University of Sydney (Australia). 2013.

The following thesis and accompanying visual practice investigates the possibilities for an artist's embodied actions to intervene within the amorphous, technological field of tourism. The research and the artwork that has developed from it has drawn upon the expanse of tourism's history and contemporary theories of its globalised politics to enact a deconstruction of the power of contemporary tourism. This thesis investigates critical, interventionist strategies in artistic practice and, importantly, examines artists who have also used these strategies of practice to critique tourism; artists such as Ai Weiwei, Isa Genzken, Emily Jacir, Martha Rosler and Yin Xuizhen. The research enquires into interventionist

strategies to create an embodied moment of dissent. The works that have been developed in relation to tourism's broad field are intrinsic to the urban environment. They highlight contemporary spaces that are increasingly touristic, and immersed in the ephemera of the globalised, mediated landscape. It asserts that the art developed within this disciplinary area should be open-ended, experimental and ephemeral in order to be inserted effectively within the fluid space of production and experience. [Author Abstract]

9.) **Liu, I.**
Research on the contemporary artist Ai Weiwei - A side write about the archetype of the eschatological hero or the rise of the hero.
M.A. thesis, National Cheng Kung University Institute of Art Studies (Taiwan). 2015.

The core value of this paper is in the perspective of "Hero", to explore the concept artist Ai Weiwei prototype associated with heroes, and cited the Joseph Campbell(1904-1987)'s theory, form the outline of the hero image .The paper first sets out Ai Weiwei's work shape and its meaning divided into four categories of creation: readymade, installation art, video records, and performance art (including Internet media phenomenon).Secondly, let's talk about artistic freedom and human rights issues, to analyze points this way; Finally, a reference to Campbell's hero theory, form the outline of the heroic image. Ai Weiwei's works are

with humorous, ironic and casual attitude, intermingled with political power, and conceptual art in the same cup, to show resistance of Izod unique aesthetics. Allowing dissident to wander boundary, so that the public's imagination between the virtual and actual inter-penetration, infiltrated into the reconstruction of the social significance of art. The other core value is: the autonomy of the art shouldn't be interfered irrationally by political ideology. The writing is mainly constructed with the discussion about the collision between art performance and political issue to achieve the artistic freedom that the writer want to show. On the way to reference some principles that citizen's civil right should enjoy maximum freedom of artistic creation and expression; another main reference is the theory of Pierre Bourdieu(1930- 2002)for creative freedom security and the power of the symbolic capital discussed in this paper. The focus of Bourdieu's thesis is: "How the artist as a

citizen of the carrier should be in the middle of the power of economic, political and other multiple symbolic capital to maintain autonomy and independence creation, and when necessary, to defend freedom of expression." The contribution of this paper is that it reiterated an important phenomenon- whether the artist with political stance when art expression involved political issues is a big challenge for him/her. In comprehensive discussion of the way, this paper tries to match Ai Weiwei's with Hero Archetype at the beginning of ideas. Then discuss the various aesthetics means of media campaigns and Political civic forum, and fully attain it's Contemporary. Finally, as the open-ended conclusion, hope for future successor to prove it from the development of the artist since the heart step by step. [Author Abstract]

10.) **Merki, P.**
Censorship in Chinese media: A comparison of Ai Weiwei and Han Han.
B.A. thesis, St. Gallen University (Switzerland). 2014.

Chinese media censorship is an issue regularly raised by foreign politicians and in foreign reports. This thesis seeks to add to this discussion by taking into consideration the opinion of two bloggers, Ai Weiwei and Han Han, writing under the constraint of Chinese Internet censorship. How they transmitted the censorship issue to the Chinese readership of their blogs is considered to reveal and compare their opinions. It is found that both authors oppose censorship and call for freedom of speech. However, their views differ concerning concrete aspects of censorship, with Han Han taking a more moderate approach to the issue than Ai Weiwei. [Author Abstract]

11.) **Parker, L. M.**
Incipiendum, Ad Infinitum: Considerations for an ethicopolitical framework and the potential for art as its expression.
Ph.D. dissertation, York University (Canada). 2015.

In this work, I delineate the foundations for an ethical politics toward societal transformation, paying particular attention to how the process can be expressed using the arts. I do not advocate for a particular hegemony, but, in the course of explicating the framework, will describe certain epistemological or ontological tenets that are necessary in order for the process to unfold. I begin with an outline of what I mean by an ethical politics, turning to Levinas, Rancière, and Arendt to lay the groundwork for the importance of the other, and to establish the significance of beginning, of moving toward what always lies beyond the horizon. From there, I build

an argument that the arts can offer a unique and important means of realising the ethicopolitical process, since they can function as both an other and an interruption. Because not all art can be considered an other or an interruption, I distinguish between art as interruptive, or art for the political, and art that that conforms or extends the values and principles of the state. Upon preparing the rudiments of the ethicopolitical framework and clarifying which types of art may be utilised in the process, I trace how art, through the sub-processes of inspiration and realisation, can represent the ethicopolitical steps of listening and speaking. I also address why I believe art is a unique expression of the ethicopolitical process, because of its inherent appeal to affect. I elaborate the framework using a case study of the Chinese artist and dissident, Ai Weiwei. In conclusion, I suggest that in order to preserve and nurture the promise ofarts

as an interruption toward sociopolitical transformation, a particular kind of pedagogy is required. [Author Abstract]

12.) **Quick, G. C.**

Art and the politics of Neoliberal subjectivity: The activist artist in the East Village, 1981-1993.

M.A. thesis, Tufts University. 2015.

This thesis examines contemporary political art in New York City's East Village as set against the neoliberal political economy of the 1980s, arguing for the formation of a characteristically ambivalent subject-position exemplified by certain activist artists and their work. The introduction surveys key examples of East Village art and its positions within neoliberalism and postmodernity. Chapter 1 analyzes the work Ai Weiwei produced during the time he spent living in the East Village. Ai's work in this context reacted to commodification and gentrification. Chapter 2 examines the roles of individualism and autobiography in David Wojnarowicz's art before and after he became an AIDS activist, arguing for the

political utility of those qualities. The concluding chapter widens the scope of focus to New York and American urban spaces more broadly by discussing the work of David Hammons, which addressed similar issues to those raised in previous chapters. [Author Abstract]

13.) **Sikes, E.**

A matter of perspective: Anti-authoritarian gestures in the political art of Ai Weiwei.
M.A. thesis, University of Cincinnati. 2013.

Ai Weiwei has emerged as an important politically active force on the international art scene in the last 5 years. The artist's background and his two series, A Study of Perspective and Dropping the Urn, both began in 1995, played a major role in launching him to international fame as a political activist and artist. In my introduction, I will introduce Ai Weiwei and establish his place in the world as a politically active artist working in China. In subsequent chapters, I will discuss A Study of Perspective and Dropping the Urn in terms of how they, by offering an idea of dissensual thought towards pre-existing notions of

reverence for monuments and artifacts were at the forefront of his political art-making career and his political activism. [Author Abstract]

14.) **Wang, W.**
Censorship and subtle subversion in Chinese contemporary art.
M.A. thesis, Sotheby's Institute of Art - New York. 2014.

Chinese authorities have conflicting feelings toward contemporary art. Although contemporary art has become an important part of a national branding strategy for China's self-promotion, the government continues to heavily regulate civil society and state censorship of visual art. Artists in China still face a confusingly vague boundary between artistic experimentation and political correctness. This thesis explores the definition and standard of censorship imposed on contemporary art in China by analyzing previously censored works from artists including the Gao Brothers, Huang Rui, Zhang Hongtu, Shen Qi, and Ai Weiwei. This study additionally investigates strategies and frameworks like subtle or parodic

language that artists like Song Dong, Qiu Zhijie, and Polit-Sheer-Form Office have adopted to successfully convey their personal opinions while avoiding censorship. [Author Abstract]

15.) **Yu, T.**
'My' self on camera: First person DV documentary filmmaking in twenty-first century China.
Ph.D. dissertation, University of Westminster (United Kingdom). 2012.

This project explores first person DV documentary filmmaking practice in China in the first decade of the twenty-first century. Building on existing studies of first person filmmaking in the West, which predominantly analyse filmic self-representation on the textual level, this study addresses two themes: the film text as an aesthetic and cultural object that constructs a self; and the filmmaking as a practice and a form of social participation, through which individual filmmakers as agents actively construct representations of their own selves and their subjectivities. Focusing on the work of nine filmmakers, including Yang Lina, Shu Haolun, Hu Xinyu, Wu Haohao, and Ai Weiwei, I

argue that these films illustrate the makers' individual selves as multi-layered and conflicted, situated in complex familial and social relationships, and in the changing relations between individuals and the state. In addition, this practice can be seen as a form of provocative social participation in the era of 'depoliticised politics', that stimulates important individual critical thinking and helps to form a new kind of political subjectivity, to reconstruct political value and reactivate the political space in China. These films and the filmmaking practice not only reflect some aspects of the changing concept of individual self in contemporary China, but can be seen as a generative and constructive process, that further contribute to the changing constitution of the individual subject in China. Through close textual analysis of this body of first person films and this filmmaking practice, I demonstrate features of the complex changing relations between the public (gonggong) and the

private (siren) space, between the collective (jiti) and the personal (geren), and between the individual (geti) and the party-state (dangguo) in post-socialist China. The project aims to contribute to current debates in the international field of first person filmmaking, and to studies of contemporary China. [Author Abstract]

16.) **Zheng, B.**
The Pursuit of publicness: A study of four Chinese contemporary art projects.
Ph.D. dissertation, University of Rochester. 2012.

This dissertation examines the meaning of publicness and its relationship to contemporary art through an analysis of four Chinese art projects. The four projects are Moving Rainbow (1998-2001) by Xiong Wenyun, Village Self-Governance Documentary Project (2005) by Wu Wenguang, Karibu Islands (2008) by myself, and Nian (2010) by Ai Weiwei. I demonstrate that these projects share a number of things in common: (1) the artists and participants acted as citizens and demanded citizens' rights; (2) they organized discursive arenas outside the state; (3) they defined issues of common concern; (4) they mobilized both rational-critical and affective expressions, and utilized a wide range of media; (5) they

fostered stranger relations; (6) they strove for visibility; (7) they focused on contemporary common action. These traits together constitute publicness. Publicness not only served as a goal for these projects, but also constituted a form through which these projects came into being. I argue that the pursuit of publicness has been one of the critical forces motivating the development of Chinese contemporary art. In the struggle against totalitarianism, Chinese artists have combined public and counterpublic strategies and contributed to larger social movements striving for freedom and justice.. [Author Abstract]

Locating Dissertations and Theses

A. Purchase

Many of the dissertations and theses listed in this bibliography are available for purchase through UMI Dissertation Express:

> http://disexpress.umi.com/dxweb

By Fax:

> 800-864-0019

By Mail:

> 789 E. Eisenhower Parkway, P.O. Box 1346, Ann Arbor, Michigan 48106-1346
>
> 800-521-3042

B. Interlibrary Loan

Dissertations and theses may also be requested through Interlibrary Loan via your local public, college or university library.

www.ingramcontent.com/pod-product-compliance
Lightning Source LLC
Chambersburg PA
CBHW070413190526
45169CB00003B/1239